GW00368064

Finding Our Selves

Insights for Young Women

Edited by Suzanne Monges

Illustrated by Diane Bigda

Ariel Books

**Andrews McMeel
Publishing**

Kansas City

www.andrewsmcmeel.com

ISBN: 0-7407-0064-2

Library of Congress Catalog Card Number: 99-60620

Contents

Introduction

The transformation from a girl into a woman has never been easy. As our roles and responsibilities change and grow, women have an ever greater need for role models and good advice.

The quotations in this volume will remind you of the tools you need to make the most of wom-

anhood—laughter, love, and self-confidence. Take these words of advice and experience with you as you dive into the rich, exciting, and often unpredictable world of womanhood.

Finding Our Selves

Live, Learn, Love

One is not born, but rather
becomes, a woman.
 —Simone de Beauvoir

Growing up is, after all, only
the understanding that one's
unique and incredible experi-
ence is what everyone shares.
　　—Doris Lessing

Finding Our Selves

\mathcal{N}obody ever was—or ever again will be—as green as I was the day I landed in New York. That shade has been discontinued.

—*Carolyn Kenmore*

Life forms illogical patterns. It is haphazard and full of beauties which I try to catch as they fly by, for who knows whether any of them will ever return?
—*Margot Fonteyn*

Life is what we make it, always has been, always will be.
—*Grandma Moses*

Finding Our Selves

You must learn day by day, year by year, to broaden your horizon. The more things you love, the more you are interested in, the more you enjoy, the more you are indignant about, the more you have left when anything happens.

—*Ethel Barrymore*

Finding Our Selves

I began to have an idea of my life, not as the slow shaping of achievement to fit my preconceived purposes, but as the gradual discovery and growth of a purpose which I did not know.
—Joanna Field

I soon realized that no journey carries one far unless, as it extends into the world around us, it goes an equal distance into the world within.

—*Lillian Smith*

What is at the summit of courage, I think, is freedom. The freedom that comes with the knowledge that no earthly thing can break you.

—*Paula Giddings*

Life's under no obligation to give us what we expect.

—*Margaret Mitchell*

From a timid, shy girl I had become a woman of resolute character, who could no longer be frightened by the struggle with troubles.
—*Anna Dostoevsky*

I'm afraid I'm an incorrigible life-lover, life-wonderer, and adventurer.
—*Edith Wharton*

*L*ife's challenges are not sup-
posed to paralyze you, they're
supposed to help you discover
who you are.

—*Bernice Johnson Reagon*

I have always grown from my
problems and challenges, from
the things that don't work out,
that's when I've really learned.

—*Carol Burnett*

Finding Our Selves

. . . As one goes through life one learns that if you don't paddle your own canoe, you don't move.

—*Katharine Hepburn*

I have the feeling now that one changes from day to day, and that after a few years have passed one has completely altered. Examine myself as I may, I can no longer find the slightest trace of the anxious, agitated individual of those years, so discontented with herself, so out of patience with others.

—*George Sand*

Everything is ambiguous. It's exciting, in a way, if you can tolerate ambiguity. I can't, but I'm taking a course where it's taught, in the hope of acquiring the skill. It's called Modern Living, and you get no credit.

—Sheila Ballantyne

Finding Our Selves

*L*earning to live with what
you're born with
is the process,
the involvement,
the making of a life.
—Diane Wakoski

*G*rowing up is like taking
down the sides of your house
and letting strangers walk in.
—Maureen Daly

There is only one history of any importance, and it is the history of what you once believed in, and the history of what you came to believe in.
—Kay Boyle

A finished person is a boring person.
—Anna Quindlen

Finding Our Selves

That's maturity—when you re-
alize that you've finally arrived
at a state of ignorance as pro-
found as that of your parents.
—*Elizabeth Peters*

*Troubles, like babies, grow
larger by nursing.
—*Lady Caroline Holland*

&xperience is what happens to you in the long run; the truth that finally overtakes you.
—*Katherine Anne Porter*

&any women do not recognize themselves as discriminated against; no better proof could be found of the totality of their conditioning.
—*Kate Millet*

You will wear many hats—including that of lifelong learner.
—Greta K. Nagel

It is better to learn early of the inevitable depths, for then sorrow and death take their proper place in life, and one is not afraid.
—Pearl S. Buck

Finding Our Selves

We older women who know
we aren't heroines can offer our
younger sisters, at the very least,
an honest report of what we
have learned and how we have
grown.

—Elizabeth Janeway

A man stirs me because he can be my life, the visage, the presence, the tenderness of every day, and not because he has some sort of right of possession and perturbation over me.

—*Marie Lénéru*

Finding Our Selves

Old boyfriends, many women report, make excellent cat-sitters.
—*Erika Ritter*

Life is short, and it's up to you to make it sweet.
—*Sadie Delany*

\mathcal{L}ove doesn't just sit there, like a stone, it has to be made, like bread; remade all the time, made new.

—*Ursula K. Le Guin*

When we were children, we used to think that when we were grown-up we would no longer be vulnerable. But to grow up is to accept vulnerability. . . . To be alive is to be vulnerable.

—Madeleine L'Engle

The better you feel about your-
self, the fewer limits you will
place on your ability to love.
 —*Judith Sills*

Only in growth, reform, and
change, paradoxically enough,
is true security to be found.
 —*Anne Morrow Lindbergh*

Finding Our Selves

We must not, in trying to think about how we can make a big difference, ignore the small daily differences we can make which, over time, add up to big differences that we often cannot foresee.

—Marian Wright Edelman

Finding Our Selves

That is what learning is. You suddenly understand something you've understood all your life, but in a new way.
　　—Doris Lessing

May you have the strength to enjoy your weaknesses.
　　—Florence Edwards

Making Your Way

Never let anyone take your independence away.
—*Kathy Russell*

When it comes time to do your own life, you either perpetuate your childhood or you stand on it and finally kick it out from under.

—*Rosellen Brown*

We write our own destiny. We become what we do.

—*Madame Chiang Kai-Shek*

Finding Our Selves

What a lovely surprise to dis-
cover how unlonely being alone
can be.

—*Ellen Burstyn*

I was trained by my husband. He said, "If you want a thing done—go. If not—send." I belong to that group of people who move the piano themselves.

—*Eleanor Robson Belmont*

Finding Our Selves

Women are always being tested . . . but ultimately, each of us has to define who we are individually and then do the very best job we can. . . .

—Hillary Rodham Clinton

I seldom think about my limitations, and they never make me sad. Perhaps there is just a touch of yearning at times; but it is vague, like a breeze among flowers.

—Helen Keller

Some of us just go along . . .
until that marvelous day people
stop intimidating us—or should
I say we refuse to let them intim-
idate us?
— *Peggy Lee*

\mathcal{A} woman who is willing to be herself and pursue her own potential runs not so much the risk of loneliness as the challenge of exposure to more interesting men—and people in general.

—Lorraine Hansberry

How wrong it is for woman
to expect the man to build the
world she wants, rather than
set out to create it herself.

—*Anaïs Nin*

Finding Our Selves

What a commentary on our civilization, when being alone is considered suspect; when one has to apologize for it, make excuses, hide the fact that one practices it—like a secret vice!

—*Anne Morrow Lindbergh*

Finding Our Selves

Don't ever depend on connections, baby. . . . That's like depending on someone else. Connect to yourself.
—Gloria Wade-Gayles

You have to stand for something or you'll fall for anything.
—Linda J. Henderson

Finding Our Selves

When you get into a tight place and everything goes against you, till it seems as though you could not hang on a minute longer, never give up then, for that is just the place and time that the tide will turn.

—Harriet Beecher Stowe

Nobody's Perfect

A mistake is simply another
way of doing things.
 —Katherine Graham

You may have a fresh start any moment you choose, for this thing that we call "failure" is not the falling down, but the staying down.
— Mary Pickford

We don't make mistakes. We just have learnings.
— Anne Wilson Schaef

Finding Our Selves

You must accept that you might fail; then, if you do your best and still don't win, at least you can be satisfied that you've tried. If you don't accept failure as a possibility, you don't set high goals, you don't branch out, you don't try—you don't take the risk.

—Rosalynn Carter

One loses many laughs by not laughing at oneself.
 —*Sara Jeannette Duncan*

If I had to live my life over again, I'd dare to make more mistakes next time.
 —*Nadine Stair*

Finding Our Selves

*I*f you haven't forgiven your-
self something, how can you
forgive others?

—Dolores Huerta

Tools of the Trade

*L*ife shrinks or expands in proportion to one's courage.
—*Anaïs Nin*

One is happy as a result of one's own efforts, once one knows the necessary ingredients of happiness—simple tastes, a certain degree of courage, self-denial to a point, love of work, and, above all, a clear conscience. Happiness is no vague dream, of that I now feel certain.
 —George Sand

Finding Our Selves

\mathcal{M}y only advice is to stay aware, listen carefully, and yell for help if you need it.
—*Judy Blume*

Humor is such a strong
weapon, such a strong answer.
Women have to make jokes
about themselves, laugh about
themselves, because they have
nothing to lose.
—Agnes Varda

Finding Our Selves

Courageous risks are life giving, they help you grow, make you brave and better than you think you are.

—Joan L. Curcio

Worry less about what other people think about you, and more about what you think of them.

—Fay Weldon

I became more courageous by doing the very things I needed to be courageous for—first, a little, and badly. Then, bit by bit, more and better. Being avidly—sometimes annoyingly—curious and persistent about discovering how others were doing what I wanted to do.

—*Audre Lorde*

Finding Our Selves

You have to have confidence in your ability, and then be tough enough to follow through.

—Rosalynn Carter

I've never sought success in
order to get fame and money;
it's the talent and the passion
that count in success.
 —*Ingrid Bergman*

*A*sserting yourself while re-
specting others is a very good
way to win respect yourself.
 —*Janice LaRouche*

Finding Our Selves

Trust your gut.
 —Barbara Walters

The one important thing I have learned over the years is the difference between taking one's work seriously and taking one's self seriously. The first is imperative and the second is disastrous.
 —Margot Fonteyn

Some women wait for something to change and nothing does change so they change themselves.

—*Audre Lorde*

*I*f you are all wrapped up in yourself, you are overdressed.
—*Kate Halverson*

*D*o you know what individuality is? . . . Consciousness of will. To be conscious that you have a will and can act.
—*Katherine Mansfield*

Finding Our Selves

The essential [conditions] of everything you do . . . must be choice, love, passion.
—*Nadia Boulanger*

The secret of joy in work is contained in one word—excellence. To know how to do something well is to enjoy it.
—*Pearl S. Buck*

Finding Our Selves

I've got a woman's ability to stick to a job and get on with it when everyone else walks off and leaves it.

—*Margaret Thatcher*